Digital photography basics

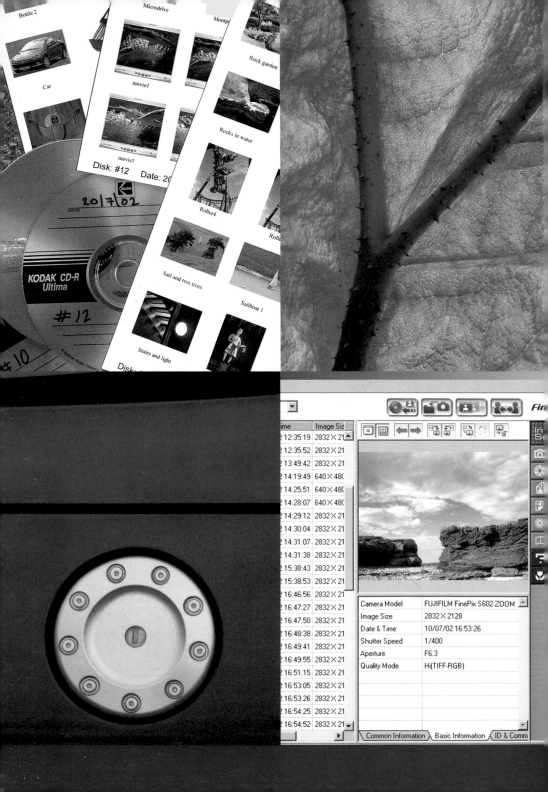

Digital Photography Basics

LES MEEHAN

COLLINS & BROWN

First published in Great Britain in 2003 by
Collins & Brown
64 Brewery Road
N7 9NT

A member of **Chrysalis** Books plc

ISBN: 1-84340-042-1

British Library Cataloguing-in-Publication Data:
A catalogue record for this book is available
from the British Library

Colour reproduction Classic Scan, Singapore
Printed by Kyodo Printing Pte Ltd, Singapore

Designed by Roger Hammond
Edited by Conor Kilgallon
Indexed by Isobel McLean
Project managed by Jane Ellis
Proofread by Beverly Jollands

Contents

The digital revolution

The rapid advance of digital image technology has caused at least as much, and probably more, of a revolution in photography as did the progression from wet glass plates to flexible film. Whereas film removed the need to take a complete darkroom along whenever photography was engaged in, digital imaging has removed the need for a darkroom altogether.

Many heated debates take place across the world, especially on the internet, among photographers discussing the potential demise of silver-based photography. While it is true that digital imaging is at the forefront of nearly every photographic manufacturer marketing strategy, this is not necessarily anything to do with the silver versus digital argument. These companies simply recognize the potential of digital imaging to make them money. Many people in the photographic retail trade are acutely aware that this can give a false impression of the reality and that silver-based photography will continue well into the future.

Traditional Skills

The fact is, digital imaging and traditional photography have a great deal in common. Everything that happens prior to the moment of exposure of a scene in a camera depends more on the skill of the photographer and less on how the image is to be captured. Lighting skill, model posing, having a 'good eye', are the traditional image creation skills of the photographer, and are as important now as in the past.

What the digital revolution has done is to make the enhancement and printing of photographs easier. Photographers now have the creative freedom of an artist working with paint on canvas: limited only by the imagination and the ability to master the new technical skills that digital imaging demands.

Exploring digital imaging

Digital imaging has had great impact in both the professional arena and the casual user market. It is in the latter where the greatest camera activity is to be found, as can be seen by the huge number of easy-to-use digital compact cameras appearing almost every month. Combine this with the growth in the use of home computers and reasonably priced photo quality printers and it is easy to see why more and more people are having fun trying their hand at digital imaging.

Photographers at all levels are still at the exploratory stage with digital cameras, and the traditional techniques of the photographer have been supplemented by a whole new way of working and thinking. This can only be healthy for photography generally. Digital imaging at all levels is here to stay and it will continue to improve in terms of quality and price so enjoy the new found creative freedom and fun that digital imaging can bring.

On reflection

Digital imaging has turned the world of photography on its head, providing new ways to have fun with pictures.

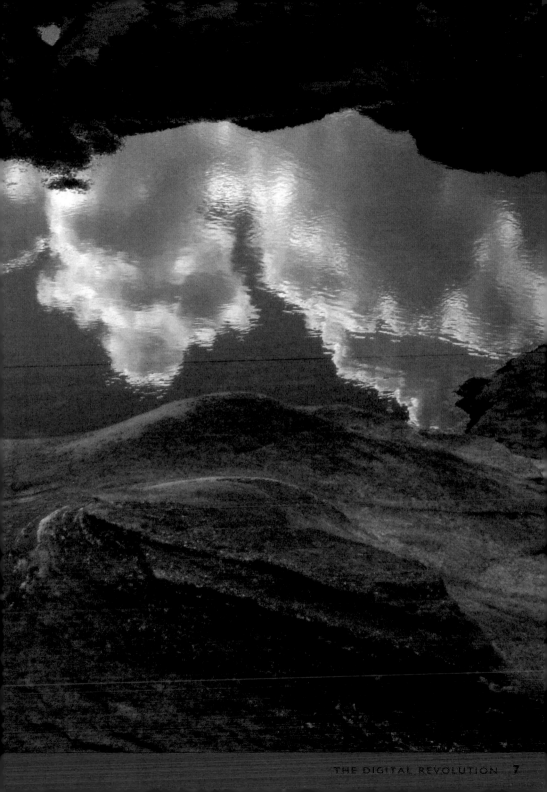

How to use this book

This book is aimed at readers who have recently invested in a digital compact camera, or are thinking of doing so. Many people are making the change from the traditional format of film to the newer format of digital imaging, and finding themselves thrust into a bewildering world of high technology. Digital camera technology has introduced a whole host of new features and techniques which are not possible with film cameras. Unfortunately, all this exciting new technology can sometimes be intimidating. Even 'happy snappers' are now faced with technical words like pixel, resolution, and megabyte,

as well as acronyms like USB, TIFF, and DPOF. More traditional photographic terminology and techniques still need to be understood as well.

This book aims to explain, in simple language, how many of the features on a digital camera work, and to provide practical tips on using them effectively. Since each feature is dealt with separately, the book makes it easy to explore only those features found on your particular camera. If you are thinking of buying a digital camera, the no-nonsense feature-by-feature explanations are of particular value in deciding which camera will best suit your needs. Some of the

1. Digital basics: sets out all the essential information necessary to understand and fully utilize a digital camera.

2. Basic camera features: examines the more common features likely to be found on most digital cameras. This section will be of use to every reader, whether you own a very simple or a more sophisticated model of camera.

features discussed may be unique to a particular make and model of camera; I have included these because I consider them of particular value for practical picture-taking.

The book is divided into five main parts, making it easy either to read through from start to finish or just to dip into for information on a specific topic. However, it is not just a list of digital camera features; it also explains many photography techniques and offers tips alongside the explanations of what your camera can do. These will help you get the most from your camera and hence improve your pictures.

3. **Advanced camera features:** deals with the more sophisticated features that are unique to digital cameras. This section will allow you to really get the most out of your camera's more advanced options.

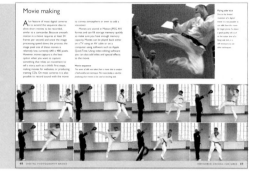

4. **Making sense of software:** shows you the use of some of the computer programs supplied with the various cameras. Those without a computer can simply skip this section if desired.

5. **Outputting images:** explores the options available for making prints from your digital image files. This section deals with both home-produced printing and using professional labs or print shops.

Digital compact cameras – overview

Probably the largest number of cameras sold worldwide fall into the category known as compact cameras. Traditionally, compact cameras were defined as those cameras having a simple lens and a direct viewfinder (where you see what the camera is pointing at). The most famous is probably the Kodak Box Brownie, which revolutionized photography for everyone in the mid 20th-century.

As cameras progressed and became more sophisticated, it became common for compact cameras to have a zoom lens to extend the picture-taking possibilities. Built-in light meters and automatic features also extended the practical options of the compact camera. It is no surprise that digital compact cameras have continued this progress and now represent the fastest growing market in photography.

The mass market appeal of digital compact cameras is reflected in the vast number of different models available from the various manufacturers. At the time of writing, one major manufacturer has at least 17 different models in the compact camera category at a wide range of prices. The other manufacturers have a similar range on offer. It's little wonder that people find it hard to decide which camera to buy. Even the least expensive digital compact camera now boasts an impressive feature

Digital camera features

These illustrations show the basic front and rear layout of a typical digital compact camera. All the most frequently used controls are conveniently located for easy operation.

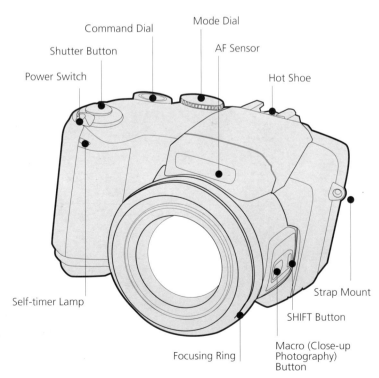

Command Dial
Mode Dial
Shutter Button
AF Sensor
Power Switch
Hot Shoe
Self-timer Lamp
Strap Mount
SHIFT Button
Focusing Ring
Macro (Close-up Photography) Button

list at a price that is affordable by nearly everyone. More expensive cameras offer better quality and more features.

Image quality

With film-based cameras, image quality is mainly dependent upon the quality of the lens on the camera since the film quality is the same no matter which camera it is used in. This is not the case with digital cameras. These present us with a situation where image quality depends not just on the lens of the camera, but also on the sophistication of the electronic device used to capture the light passing through that lens.

One of the negative aspects of this is that, whereas with film you can have larger, reasonable quality prints made from even a very cheap camera, with digital cameras the image quality produced by the cheapest cameras is not good enough to enlarge beyond normal postcard size. The high-priced SLR (single lens reflex) digital 35mm cameras have only recently reached a sufficient level of image quality to permit larger exhibition-size prints to be made. Of course, as the technology progresses, the quality/price ratio will improve in favour of the customer.

What sets digital compact cameras apart from their film-based counterparts is the amazing range of features that are only possible when the image is in digital form. These features, such as previewing the picture or deleting unwanted images, are simply impossible in a film-based camera.

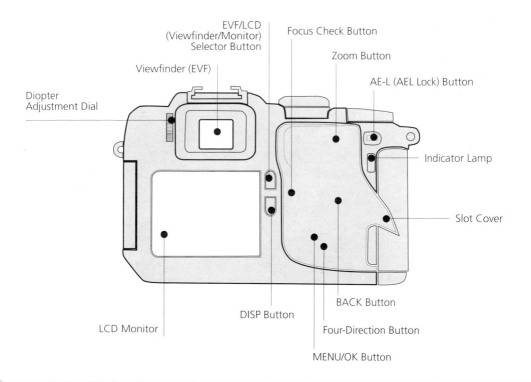

EVF/LCD
(Viewfinder/Monitor)
Selector Button

Focus Check Button

Zoom Button

Viewfinder (EVF)

AE-L (AEL Lock) Button

Diopter
Adjustment Dial

Indicator Lamp

Slot Cover

BACK Button

DISP Button

LCD Monitor

Four-Direction Button

MENU/OK Button

Digital basics

Before delving into the individual features of digital cameras, it is useful to understand some of the basic concepts of digital image formation and how image information is stored. Although this is not an in-depth technical book, nevertheless it is worth setting out the basics of how digital images are formed. This basic knowledge will assist you when you are choosing and using a new digital camera.

This section will take a brief look at how light is captured by a digital camera, how we define image quality and size, the common ways in which this information is recorded and the various storage methods available for digital cameras. Understanding this information and applying it when using a digital camera will give you more flexibility and allow you to be more creative.

Digital landscape
Whatever your level of interest in making digital photographs, a reasonable knowledge of digital basics will help you to be more successful in capturing a subject in the way you desire.

Digital image capture

The main difference between a digital and a film-based camera is the method used to capture the image formed by the light passing through the lens. Rather than use photographic film, digital cameras react to the image-forming light electronically using a CCD or charge coupled device.

The CCD contains millions of light-sensitive electronic sensors, called pixels, each of which responds to the amount of light reaching it. The information gathered by each pixel (short for picture element) is transformed using sophisticated software into the actual image pixels recorded by the camera to form the picture.

TOP TIP

When comparing cameras make sure you check the number of 'effective image pixels' and not the physical number of pixels produced by the CCD.

As there is a physical limit to how small each sensor can be made, the manufacturers use ingenious ways to increase the effective number of pixels produced by the CCD. It is only the effective pixels that contribute to the final picture quality. Generally, the higher the number of effective pixels, the better the image quality.

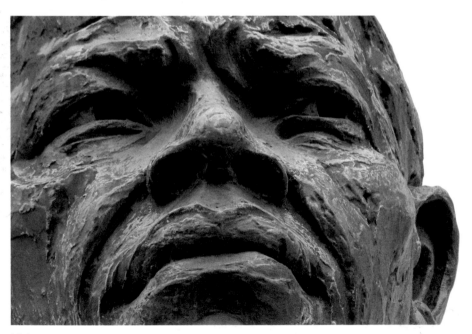

Visionary

This 'portrait' of a bust of Nelson Mandela shows that in the right hands digital cameras are capable of more creative results than mere snapshots.

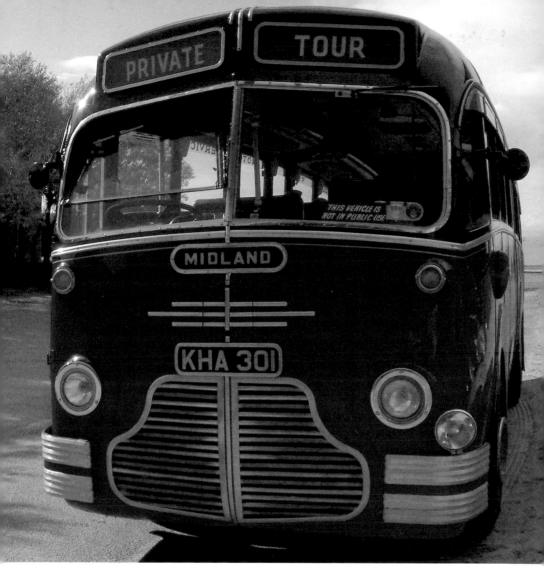

Vintage bus

Digital cameras can record good detail and excellent colour.

Physical vs. effective pixels

Not all of the pixels on a CCD contribute to the final picture. Simply stating the number of physical pixels on the CCD does not give an accurate reflection of the actual image quality. To avoid confusion to the user most manufacturers now state the number of effective pixels produced. This gives a more accurate method of comparing cameras from different makers.

Pixels and resolution

The smallest unit of visual information in a digital picture is one pixel and in general the more original pixels an image contains the higher the quality. The original pixel data is that captured by the camera at the time the picture is taken. Normally, the more effective pixels the camera produces the better the image quality, since the camera can record finer detail. However, pixel quantity is only one aspect of image quality.

Image size

There are different ways to specify the image quality of a camera using pixels. The two commonest are to state the file size in megapixels (millions of pixels) or to specify the image dimensions in pixels, e.g. 2560 x

1920 pixels. The megapixel size gives a quick way of comparing two cameras, e.g. a 3.2 megapixel camera produces smaller images than a 5.0 megapixel type. Specifying the actual image size in pixels is more useful because it allows you to determine how big your final prints can be.

Resolution

Another common term used when discussing digital images is resolution. In simple terms, resolution refers to the number of pixels contained in one unit of measurement, e.g. one inch. Resolution is used differently in various situations but for general purposes it is useful to refer to resolution in the context of printing or viewing your digital images.

Image size

These car images print at different sizes because their file sizes vary. The largest has a file size of 9.17Mb and the others are 1.7Mb and 0.5Mb. As shown, the smaller the file size the smaller the print.

Resolution and print sizes

Most camera users want to have prints of their images and it is in this context that understanding the relationship between resolution and image size is useful. For top quality prints it is normal to use a resolution of 300 dpi (dots per inch). Each pixel of the digital image produces one dot on the print. Therefore, every 300 pixels in the image gives one linear inch on a print.

Hence, an image of 2560 x 1920 pixels will produce a final print size at 300dpi of around 8 x 6in (21 x 15.5cm). Using a lower image resolution will produce a bigger print but with less quality. However, increasing the image resolution above 300dpi will not yield a better quality print, only a smaller one.

Resolution (above)

This is the full image at the optimum resolution for printing of 300dpi. It has good sharpness and colour. The enlarged sections shown in the following sequence show the effect of different resolutions on sharpness and detail.

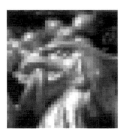

1. At a resolution of only 5dpi the image detail is reduced to squares of colour. There is not enough resolution to form a proper image.

2. At 20dpi the individual blocks of colour are now smaller and the image starts to be recognizable. There is now four times as much image information as in image 1.

3. Doubling the resolution to 40dpi increases the detail further but the edges of the detail are still pixellated.

4. At 160dpi the image is now beginning to be acceptable at this print size. Details are sharper and clearer and any pixellation is now harder to see.

5. At 300dpi the image is optimum for this print size and produces the best result. Note the subtle details and lines are now showing without pixellation.

File formats

Over time various ways have been devised of organizing graphics information within a digital data file. There are different types of computer graphics, such as photos, drawn illustrations and 3D models, and each benefits from a different method of organization within a file. These different methods are referred to as file formats.

Photographic images, which usually contain smooth gradations of tone and colour, as well as fine details, mostly use either the TIFF or JPEG file formats. These file formats have been optimized to compress the size of photographic images so they require less storage space when saved.

Besides the standard TIFF and JPEG formats, digital cameras utilize several

TOP TIP

The format of a graphics file can usually be determined by the letters at the end of the file name, e.g. tiff, jpeg, and avi.

variations of these formats that take advantage of the unique features of digital capture. For example, cameras that allow continuous movie recording save the individual frames of the sequence in a special format known as AVI or Motion JPEG. These can be played on your computer as movies using special playback software such as Apple's QuickTime viewer.

Digital cameras that allow voice memos and sound to be recorded store this in a special WAVE file format.

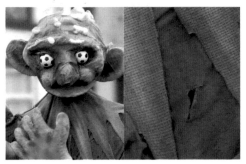

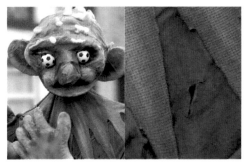

TIFF image
The standard used most for print output is the TIFF image format. This format is ideal for photographic images.

TIFF detail
This detail from the TIFF file shows there is no loss of quality when the image is saved.

JPEG image
The JPEG format is ideal for web-based photo images but each time the image is saved some quality is lost since it is compressed again on each save.

JPEG detail
This detail shows how the JPEG image quality can deteriorate after the image has been saved several times.

Image file formats

TIFF – Tagged-Image File Format
Even when compressed TIFF files retain full photographic image quality. This format uses a lossless compression method. This is the format preferred in the printing industry where high quality must be maintained.

JPEG – Joint Photographic Experts Group
This format was devised specifically to provide a compression system that would retain acceptable quality but result in small file sizes. JPEG uses a lossy compression system, so the more a file is compressed the lower the quality of the final image. JPEG is very useful for photo images destined for the internet, where small file sizes allow faster download times. One major problem with JPEGs is that each time you save the file it is re-compressed, resulting in a gradual lose of quality after each save.

AVI – Audio Video Interleave
This is the standard Windows video format for storing movies with sound. A sequence of individual still images and sound are stored together in one file and played back as a movie.

RAW – Raw data
Many digital cameras allow the image to be stored in RAW format which saves it as a string of bytes. Although this is the most basic state the image can be saved in, it is quite a useful format because the captured data is not changed at all by the camera software. This allows the purest start for manipulation of the image on a computer.

Movie sequence

This sequence of images is taken from a movie stored in AVI format. Compact digital cameras record a series of still images in motion JPEG format and combine them into an AVI movie file.

Storage systems

There are various storage systems available for use with digital cameras on which to save your pictures for later use. The most cost-effective storage media found on most digital cameras are the CompactFlash™ and SmartMedia™ memory cards (also known as media cards or media). These are available in various capacities from 16Mb to 512Mb or more.

More sophisticated cameras are likely to permit the use of MicroDrive(tm) cards, which have much greater storage capacity and thus allow more pictures to be taken in one session. Microdrives typically have a capacity of 512Mb or 1Gb (Gigabyte).

The number of pictures that can be stored on a particular card size will depend on the pixel dimensions of each image and the quality level used when taking the shot. The quality of an image is affected by the amount of compression used when saving

Formatting storage media

New memory cards and microdrives are prepared by the manufacturer using a process known as formatting. Formatting checks the media for faults and creates a standard file and folder structure, thus making it possible to start saving images. However, if you insert unformatted media in the camera a message will appear warning you that formatting is required. Formatting can be used on previously formatted media but be warned: formatting destroys ALL data already on the media.

the file. The higher the quality used to take the picture the fewer images can be stored on the memory card.

Most cameras have menu commands that allow you to delete unwanted images while out shooting, and it makes sense to save only those images you really want to keep. This will make the most efficient use of the available memory. Of course, you could buy spare memory cards or one of the portable battery-powered hard drives that allow you to transfer the contents of the memory card, thus clearing space for new pictures.

TOP TIP

Buy the largest capacity memory card for your camera that you can afford. The more memory the camera has, the more pictures you can take at one session.

Typical storage figures

For an image of 2832 x 2128 pixels the following table shows the typical number of images stored on different size media cards at various quality levels.

Mode	16Mb card	32Mb card	64Mb card	128Mb card
High	1	2	3	6
Fine	6	13	26	53
Normal	13	28	56	113
Basic	33	68	137	275

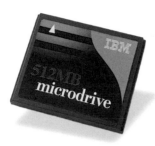

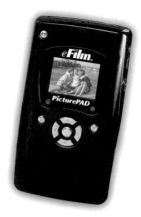

Microdrive

Developed by IBM, the Microdrive is a miniature hard disk drive that has more capacity than solid state media cards. However, these units are more fragile and do not stand rough treatment in the field.

Portable storage

There are many independent devices, such as the Delkin Devices PicturePad shown here, that permit images to be transferred from a media card and stored. Some, like the example shown, also have playback monitors.

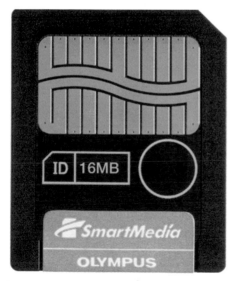

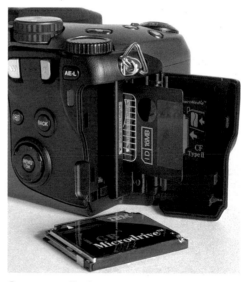

SmartMedia cards

Solid state memory cards, known as SmartMedia, are fast and robust. As development continues their memory capacity increases, allowing more images to be stored on each card. These cards provide an economical method of recording camera images.

Camera media slots

Many cameras allow both SmartMedia cards and Microdrives to be used in the same body. This image shows the twin slots available on one of the cameras made by Fuji.

2

Basic camera features

There are many features of digital compacts that are common to all makes and models irrespective of price. This section will examine several of these key features and give some advice on how to make the most of each.

Because traditional film-based cameras have had quite a long development period, the features common to each tend to be implemented in a very similar way by each manufacturer. This makes it easy to learn and write about those features and for the user to change from one camera to another without much problem. With digital cameras things are not so easy. Each manufacturer is constantly looking for new ways to implement their camera features and, because we are still at the early development stage, no common method can be guaranteed. Therefore, the descriptions of the features found in this section will be as general as possible to make them applicable to the widest range of cameras. The important point is that you understand the underlying principles of each feature and what it does in a practical way. This will allow you to explore your own particular camera with confidence.

Car detail

As with automobiles, digital cameras are fitted with a standard range of basic features which are common to most models.

Viewfinders and LCD displays

The viewfinder is the part of the camera you look through to see what you are pointing at and what will be recorded when you take the picture. On digital cameras the viewfinder may be either a direct optical system or the newer digital type.

Viewfinders

Direct optical viewfinders use a basic lens system and work in the same way on both film-based and digital cameras. You place your eye close to the viewfinder at the back of the camera and point the camera at the subject or scene you wish to photograph. If the camera has a zoom lens the optical viewfinder may have marks showing what various zoom positions will capture.

More sophisticated models replace the optical viewfinder with an electronic version (an EVF). This is a small liquid crystal display (LCD) that approximately shows what the lens will see when the picture is taken. EVFs provide compact digital cameras with one of the great advantages of the more traditional SLR camera: the viewfinder shows the image seen by the lens and so avoids the parallax problem of direct optical viewfinders (see below). On many cameras the electronic viewfinder can also be used to view the

Normal subject distances
When using a direct optical viewfinder, photographing from a reasonable distance causes no problems and the image recorded will be almost the same as the image seen through the optical viewfinder.

Parallax effect
These two close-up images show what happens as you move close enough to the subject for the parallax effect to occur. The difference between what is seen in the optical viewfinder (above) and what is actually seen by the lens (below) can be quite dramatic. When working closer than about 12in (30cm) it is important to compensate for the parallax effect.

camera settings and menus, allowing you to operate the camera without removing it from your eye.

LCD preview displays

Most digital cameras are equipped with a LCD preview screen on the back. This shows the picture almost immediately after taking the shot. The preview screen is also where the various camera menus and settings are displayed.

Once the picture is displayed you can use any image enhancement features the camera provides to modify the image as desired. If you are not happy with the picture you can delete it and take another shot for a better result.

One problem with LCD preview screens is that they can be difficult to see

TOP TIP

If your camera has an electronic viewfinder, use this more than the LCD monitor since it consumes less battery power. Also, switch the LCD monitor off when not in use.

properly, especially in bright light, and they do not show the full quality of the actual image file. For this reason it takes some practice to make the most of the preview screen and interpret what it shows correctly. Some models are equipped with a histogram feature, on which the image can be judged graphically with greater accuracy (see pages 56–57). The main disadvantage of a LCD monitor is that it drains the camera batteries fairly quickly.

The LCD monitor on most cameras changes depending on the angle it is viewed from. The three images shown here demonstrate the problem. The first image shows the monitor viewed straight on: this is the best position. As the

other pictures show, tilting the camera even slightly causes the display to change dramatically. When trying to check a picture on the LCD monitor, be sure you view the screen correctly or you may not obtain the image you expected.

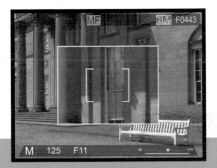

Electronic viewfinder

This image shows how a typical EVF appears as you look through the camera. All the relevant technical information is shown around the image. The centre of the image can be enlarged to help fine-tune the manual focus.

Optical zoom

Many digital compacts are fitted with a zoom lens. A zoom lens has the advantage of allowing you to control how much of the subject is included in your picture without having to alter your distance from the subject.

The actual focal length of these lenses is smaller than a traditional 35mm film camera because the CCD is often smaller than film. To make it easier for many people to understand, the zoom range of a digital camera is usually given in terms of it's 35mm equivalent, e.g. a 38–115mm equivalent lens. This is because many users are already familiar with 35mm film camera lenses.

The focal range of the lens is referred to as the optical zoom range. One advantage of using a zoom lens is that the digital image quality remains constant throughout the zoom range. The image quality is constant because the whole digital CCD area is used to capture the image.

Monument plaque

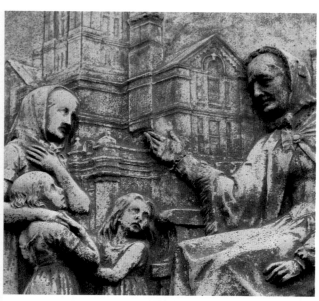

PROBLEM

Can't get close to the subject
This plaque was surrounded by a chain fence and I wasn't able to get closer. The image was made with the lens set to 50mm focal length. Having to look up at the plaque has also produced distortion.

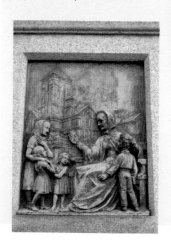

SOLUTION

Plaque detail
By stepping back and then zooming in, I was able to show a detail. Changing my position not only produces a stronger image but also helps to reduce the distortion of the previous image due to the change in perspective.

Roadside trees

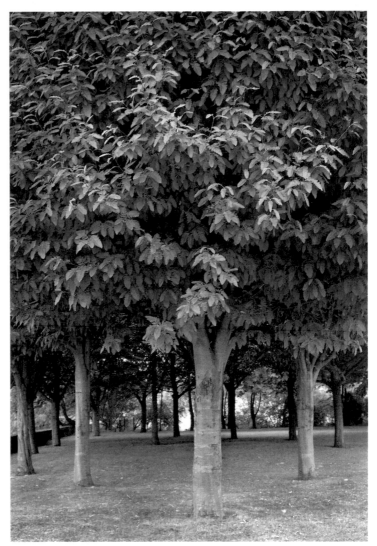

PROBLEM

Original scene looks cluttered

I liked the arrangement of tree trunks, but moving the camera closer (to exclude some of the distracting surroundings) and using the same focal length on the lens would have also changed the arrangement. Whenever the distance from the camera to the subject is changed it changes the relationship between the objects in the scene. This is known as changing perspective.

SOLUTION

Zoom in to get rid of distracting surroundings

Without changing my position, I altered the zoom lens to the maximum focal length. Now the trees are isolated from their busy surroundings. Since the distance from the camera to the trees has not changed, the perspective is the same as before. After zooming in it may be necessary to make slight adjustments to improve the result. Here, I moved slightly to the left to separate the tree trunks more.

Focus methods

Digital camera lenses are usually linked to an automatic focusing (AF) system. Individual manufacturers employ different AF systems, which means that some cameras focus better in certain situations than others. For example, AF systems that rely on bouncing a signal off the subject can be fooled if you point the camera at an angle to a wall, since the signal does not bounce back. However, these systems are excellent when the object focused on faces the camera. Other AF systems rely on comparing the contrast (light and dark areas) in the subject. These can be fooled by very dark, low contrast scenes such as when taking pictures at night.

More sophisticated AF systems use segment or area focusing for a more generalized focus, to try to get more of the subject sharp. These systems can also

TOP TIP

If photographing in dark conditions, take a torch to shine on the area you are trying to focus on. The lighter an area is the easier it is to focus on.

be used to select a specific area of the scene to be used as the focus point. This is useful if the main area of interest is not in the middle of the picture. Cameras with 'focus lock' allow the focus point to be fixed on any part of the subject, permitting re-framing of the subject.

When choosing a camera it is useful to try using the AF feature on various scenes, such as light and dark subjects and walls at an angle.

Cameras equipped with manual focus give you the freedom to choose the exact part of the subject you wish to focus the lens on. This is important when you want more control over your picture making, or when the camera's AF system simply cannot cope with the scene. One problem with manual focus is that in dark conditions it can be difficult to focus accurately due to the lack of light.

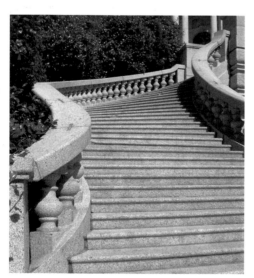

Normal auto focus

Most subjects contain enough detail and are bright enough for the auto focus system of a camera to produce accurate results. Since I wanted overall sharpness on this staircase, the auto focus and an aperture of f/11 provided the required result.

Manual focus

When the lighting conditions are quite dark, or the main subject surface tilts away from the camera (I had both conditions here), it may be better to use manual focus to obtain an accurately focused picture. Many cameras indicate when the auto focus cannot cope with a specific situation.

Offset auto focus

When the main subject is not in the centre of the picture, such as the rocks in this image, you can use AF lock. By pointing the centre of the camera at the main subject and locking the focus on this position, you can then re-compose the picture as desired. More sophisticated cameras allow you actually to move the AF location in the viewfinder away from the centre to deal with this type of subject.

Picture quality

Two aspects of digital cameras that it is essential to understand are the image pixel dimensions available and the image compression options. Understanding both of these points will help you to select the optimum settings for a given picture, to obtain the most suitable quality image and make the most efficient use of the camera's storage capacity.

Pixel dimensions

Most cameras permit you to record a subject using different pixel dimensions. Your choice of pixel dimensions depends on what the image is to be used for and how much quality is required. Higher pixel dimensions result in better quality images but each image will require more storage than images with lower pixel settings.

The images of a stained glass window in this sequence were made at different pixel dimensions using the same amount of compression. As long as each image is printed at the correct size, the impression of quality will remain similar. Printing

High **High enlarged** **Fine**

This sequence of images shows the result of using the same pixel dimensions to capture the original scene but applying different compression settings when storing the captured image data. The images were made using a Fujifilm S602

Image compression

Once the image has been recorded it needs to be stored on the camera storage media for later use. To make better use of storage space, digital cameras permit the image to be compressed as it is saved. Various amounts of compression are available and how much is applied depends on how much quality loss you are willing to tolerate in order to store more images. Different manufacturers use different terms for the compression settings on their cameras, but words like High, Fine, Normal, and Basic are in common use. Which compression setting to use depends on how much quality you wish to retain.

the lower pixel dimension images at a larger-than-optimum print size will reduce the quality of the print. However, the higher pixel images can be reduced when printed without significant loss of quality.

Normal **Basic** **Basic enlarged**

camera which has High, Fine, Normal and Basic compression settings. The two enlarged details show the marked difference in quality between the High and Basic settings.

Exposure controls

Many camera users are happy to set the camera to fully automatic because they are simply recording everyday events or holidays. On cameras that allow manual operation, which permits more creative use, it is important to understand the controls that affect subject sharpness and exposure (the 'exposure' is the amount of light allowed through the lens to record the image correctly).

The shutter

The camera's shutter controls the amount of time light is allowed to reach the CCD. The time it takes for the shutter to open and close – the shutter speed – determines the total time the light has to affect the CCD. Shutter speeds are shown as multiples of one second using a standardized scale. For very long shutter times some cameras have a bulb setting. This allows the shutter to be held open by the user for making time exposures.

Shutter speeds are also a powerful creative tool for controlling movement in a picture. Faster speeds (e.g. 1/500) tend to freeze subject movement while slower speeds (e.g. 1/30) allow subject movement to be recorded as a blur in the picture.

The aperture

An adjustable iris built into the lens of a camera controls the aperture. This iris can be opened and closed to control the

Fast shutter speed

The sharpness of moving subjects, such as this stream water, can be controlled by the choice of shutter speed. Fast shutter speeds will freeze the movement as shown here (taken at 1/250 second) which is good for retaining detail in the moving subject.

Slow (long) shutter speed

The visual impression of movement is often shown better by using a slower shutter speed which allows the moving subject to blur in the picture. The blur of the stream water in this picture, taken at 1/60 second, enhances the feeling that the water really was flowing over the rocks.

Maximum depth of field

The aperture allows the overall sharpness of the scene to be controlled. This landscape required maximum depth of field so an aperture of f/11 was used.

Minimum depth of field

When you want to make a subject stand out from a cluttered background, it is useful to reduce the depth of field by using a larger aperture as shown here (f/2.8). This is known as differential focus and is used mostly for portraits.

amount of light reaching the CCD. The size of the hole of the iris is denoted by a standard scale of numbers known as f-numbers. These numbers are usually written like fractions, e.g. f/11 or f/5.6. It is important to know that the higher the number, the smaller is the hole in the iris. As the iris is closed down, less light reaches the CCD. The combination of shutter speed and aperture is used to control the total quantity of light allowed to affect the CCD and hence form the image of the subject (see p 36).

Apart from controlling the amount of light passing through the lens, the aperture

TOP TIP

When hand-holding a camera, use a shutter speed of 1/125 second or faster to avoid camera shake blurring your picture.

also affects how much of the scene will be acceptably sharp in the final image. As the iris is closed (higher f-numbers, e.g. f/11) the subject sharpness increases in depth. Conversely, as the iris is opened (e.g. f/2.8) the subject sharpness is reduced in the picture. The area of sharpness is known as the depth of field.

Digital film speed

More advanced digital cameras allow you to select different ISO settings. As with photographic film, the higher the ISO number the more sensitive the CCD becomes to low light levels. However, unlike their film-based counterparts, digital compact cameras don't go lower than about ISO 100, or higher than about ISO 800.

Changing the ISO setting allows you to capture subjects in a wider range of lighting conditions: as the light gets darker, for example, you can continue taking pictures, without using the built-in flash, by changing to a higher ISO value. One great advantage of digital cameras over film cameras is that you can change the ISO for each individual image, as needed.

Another use for different ISO values is to allow you to get the exposure setting you want for a particular subject (see page 32). For example, in sports photography you may require fast shutter speeds in order to freeze movement. Using higher ISO values allows you to use faster shutter times for the same scene.

Low ISO setting

Bright lighting conditions allow you to use the lowest ISO setting (ISO 100) to obtain the maximum quality from your camera. In this picture of a fountain, the bright light enabled me to use a shutter speed that allowed some slight movement of the water to capture the feeling of flowing water while retaining reasonable sharpness for the rest of the image.

Medium ISO setting

These old suitcases on a restored railway station were in dull afternoon light. On the lowest ISO setting, the camera indicated that I should use flash, which was not what I wanted. Changing to the higher ISO 400 allowed me to use the shutter speed and aperture I wanted.

ISO SETTING	SUITABLE FOR
Low ISO setting (100–200)	■ Outdoor subjects in sunlight, e.g. children, holiday photos. ■ Landscape or indoor static subjects using a tripod. ■ Use when maximum image quality is required.
Medium ISO setting (250–400)	■ Dull weather scenes. ■ Capturing movement in good lighting conditions. ■ Hand-held candid shots.
High ISO setting (500–800)	■ Low-light scenes, pop concerts, night photography. ■ Capturing fast movement (e.g. sporting events) in dull or indoor conditions.

High ISO setting

In low light, as in this evening beach image, you may need to use the highest ISO setting (ISO 800). This setting produces slightly lower quality and in certain cameras can result in some unwanted side effects, such as random patches of coloured pixels in very dark or shadow areas. This is caused by electrical noise.

Exposure methods

All but the simplest cameras have a built-in light meter that measures the light from the subject and displays a recommended shutter speed and aperture (f/number). The light metering system is designed to suggest a shutter/aperture combination that will produce the best possible image of the subject. This is known as the 'required exposure.'

To make it easier for users who may not have much knowledge of how exposure control works, most cameras incorporate automatic exposure (AE) systems. The AE system measures the light from the subject and sets the controls of the camera to the appropriate settings to obtain a good exposure. AE systems have various modes that can be selected to allow the user to influence the settings chosen by the meter.

For those who have a knowledge of exposure technique and who want more creative control over their images, many cameras also have manual exposure control. This allows any combination of shutter speed and aperture to be set, based on the requirements of the user.

Spot mode

The exposure for these beach huts was determined using spot mode on manual. Two readings were taken from the bright yellow hut, one from the sunlit side and the other from the shadow side. The exposure between these two was used to make the picture.

CAMERA METER MODES

Centre-weighted	Matrix or segment mode	Spot mode	Spot AF mode
The oldest way of measuring light, the light meter reads an area of the subject seen in the lower centre part of the viewfinder. This is useful for landscapes where the bright sky may unduly affect the meter, leading to insufficient exposure to form a good image.	Most modern meter systems base the overall exposure on measurements from various areas or segments of the viewfinder image (anything from 64 to 256 different readings may be averaged by the system). This method is intended to give a more accurate exposure in vastly differing conditions.	Considered the most accurate and versatile method for the creative user wanting to control exposure, spot metering uses a small area of the subject to measure from. This area is usually indicated by markers in the viewfinder. Spot metering requires a good knowledge of exposure technique for accurate results.	This is the same as spot metering except the 'spot' can be linked to the point of the image used for auto-focusing. The idea is to obtain accurate exposure for the most important part of the picture, but there is no reason to assume that the point of focus is also the most important area to measure light from. Think about where the light areas are on a silhouette, for example.

Matrix mode

The correct exposure for this monument was found using the matrix metering mode and aperture priority to control depth of field. Matrix metering produces good results under a wide range of lighting conditions.

Taking light readings

Simply select the meter mode you want (see table below left) and point the camera at the subject to be metered. For manual mode, it is useful to take readings from both dark and light areas and choose a setting between these two to average out the exposure.

AUTO EXPOSURE MODES

Program AE
This mode selects both the shutter speed and aperture based on a control program in the camera. It is important to be aware of the shutter speeds used to avoid camera shake when hand-holding the camera in Program mode.

Aperture-priority AE
This mode allows the user to select which aperture is required. The exposure system will recommend the appropriate shutter speed to use with the selected aperture. This mode is ideal when you want to control the sharpness in the subject with the appropriate f/-number.

Shutter-priority AE
This mode is the exact opposite of aperture-priority. The user selects the desired shutter speed and the exposure system recommends the f/-number to use with that speed. This mode is useful for hand-holding (so you can keep the shutter at 1/125) and for experimenting with subject movement effects.

Manual
As previously mentioned, manual control allows the user to select both the shutter speed and f/-number, based on light meter readings taken by them using the built-in meter or a separate meter. This gives the user the fullest control over the exposure process and is important for creative work.

Overexposed **Corrected exposure** **Underexposed** **Corrected exposure**

When a subject has large areas of dark tone, as in this back-lit still life of pottery (a low-key subject), automatic metering systems usually make the picture too light, as shown here. This can be corrected either by metering from a light area (which will reduce the overall exposure) or by using exposure compensation (see pages 50–51).

When a subject has large areas of light tone (a high-key subject) as in this modified version of the pottery still life, AE systems tend to make the picture too dark. This needs to be corrected by increasing the exposure indicated by the camera.

Scene program modes

In commonly occurring situations, scene program modes use automatic exposure settings designed by the camera manufacturer to produce the best results. When photographing the specified type of subject, these automatic settings make it easier and quicker to obtain consistent results. The most common scene modes are Portrait, Landscape, Sports, Night Scene and BW (black and white). Other combinations may also be found on specific cameras.

Portrait mode

When you want your subject to stand out from a fussy background, as with this 'portrait' of a deer, set the camera to portrait program mode. This will select a wide aperture to reduce the depth of field in the picture.

BW mode

Black and white photographs can be fascinating since they rely on light and shadows for their mood. As this simple picture shows, using BW program mode allows you to remove the colour from a scene to emphasize the shapes and light of the subject.

Landscape mode

This scene required good depth of field so the camera was set to landscape program mode. This mode chose a small aperture to obtain good overall sharpness.

SCENE MODES

Portrait
Most portraits look good when the subject is sharp and the background is out of focus. This program mode achieves this result by choosing a moderate aperture (e.g. f/5.6) and a corresponding shutter speed (based on the light on the subject).

Landscape
Most landscape subjects rely on good overall sharpness and this usually requires a small aperture (e.g. f/11). Landscape program mode tries to use the most suitable aperture to obtain good sharpness in the scene.

Sports
This type of subject tends to be about action and movement and generally requires faster shutter speeds to help freeze any movement. Sport program mode therefore biases towards fast shutter speeds at the expense of overall sharpness.

Night Scene
Photography at night usually involves long exposure times using very slow shutter speeds. Normally it is necessary to use a firm support or a tripod. Night program mode usually achieves good sharpness combined with long exposure times to record the image successfully.

BW
For people who are interested in creating black and white pictures some cameras have a BW program mode which removes the colour from the scene and records it as a black and white image.

Basic flash

Digital cameras usually have a convenient built-in flash for use in low light situations such as indoors or late evening. The camera will normally warn the user when flash is recommended and may even charge the flash automatically. The warning usually assumes that the user is hand-holding the camera and needs to avoid slow shutter speeds.

Built-in flash may have different modes of operation depending on what the user requires. The usual mode is auto flash, which doesn't require any user involvement (apart from setting the camera to auto flash mode). The flash exposure is controlled with a sensor on the camera that measures the flash light bouncing back from the subject.

Dark interiors

When taking pictures indoors or in dim light, the built-in flash can be used to provide enough light to make a picture. Although the interior of this church was quite dark, I saw the potential of the gold-painted organ pipes, and used the built-in flash on auto mode to light the scene.

Arresting movement

This close-up picture of a shark's face was taken in an indoor aquarium using the built-in flash on manual mode. The flash allowed me to freeze the movement of the shark to obtain a sharp picture.

Effective range

The effective range of a flash covers the nearest and farthest distances that will produce correct exposure. If the subject is too close the flash will be too bright and if too far away the flash will be too dim. Therefore, it is important that the subject is well within the effective range.

Another standard way of specifying the power of a flash is with guide numbers. In this case, the higher the GN the more powerful the flash unit. However, guide numbers are more relevant when using separate flash units.

Natural colour

In scenes with unusual lighting, such as this artificially lit underwater scene, the built-in flash can be used to produce more colour in your picture. Here, the flash has brought out all the bright, rich colours of the fish and foliage, which were not apparent to the naked eye.

3

Advanced camera features

The previous section looked at the most common features found on digital cameras. In this section, we will look at some of the advanced features found on the more sophisticated cameras. Some topics, such as advanced flash, will expand on the basics discussed so far, whereas new topics are designed to take you deeper into digital camera systems.

Some of the features dealt with may be specific to a particular make and model of camera but these have been included to help the reader make informed choices when seeking to buy a new camera. For those readers who already have a camera with these features, the topics will broaden your knowledge and provide practical help.

Most of the topics in this section will help you produce more interesting pictures than simply 'holiday snaps' and will be of particular interest to those readers who intend pursuing digital photography as an absorbing hobby.

Window and columns
Cameras with lots of features provide more scope for creative photography. They let you have more fun, too.

Digital zoom

Nearly all compact cameras have a digital zoom feature that is primarily used to expand the capabilities of a fixed focal length lens. Cameras with real zoom lenses also use this technique to increase the apparent magnification of the lens.

Digital zooming allows the user to enlarge a small area of the original image after it has been recorded. This is usually done using the camera's LCD preview screen. Once the image area has been selected it can be saved.

Digital zooming is achieved within the camera using a technique called software interpolation. The amount of digital zooming possible depends on the image mode being used, higher image modes provide less magnification. Digital zooming always results in lower image quality since less data is used to make the final picture.

No digital zoom

This image was shot with the equivalent of a 35mm lens at the camera's highest quality setting. The image is sharp and has smooth tones and colours.

TOP TIP

Before using the digital zoom feature, move as close as possible to the subject. This will reduce the amount of digital zooming required and produce a better quality image.

Using digital zoom

This image was created from the same position as the main image by using a 4x digital zoom to isolate the buckets. The image quality is still acceptable in a small print size.

Image quality

The drawback of digital zooming is that it always results in lower image quality, since less data is used to make the final picture. This reduction in quality is due to software interpolation, which creates new pixels from existing ones.

The image on the left, shot by moving closer to the subject, is sharp and has smooth tones. The second image, shown on the right, was created using digital zooming.

Macro

Macro, or close-up photography, involves photographing objects at short distances in order to fill the frame with just a small area of a subject. Macros are commonly used in nature photography, to show, for example, the inside of a single bloom on a plant.

Advances in the quality of lenses have made it possible for even inexpensive cameras to include a macro facility. All lenses have a focus range that usually extends from around 1.5ft (0.5m) to infinity. By including a macro

mode, usually a movable element within the lens, the camera can focus on objects as close as 4in (10cm), or even less on more advanced models. This facility greatly increases your picture-taking opportunities.

Super macro

With organic subjects such as this strawberry, the wide angle effect of the super macro mode can increase the impression of roundness and the 'presence' of the subject.

Macro mode

This sequence shows how the camera can be moved progressively closer to a subject. The image above is the closest, 19.5in (50cm), the lens will focus without macro. The image above right was made at the closest macro distance of 4in (10cm). The third image, right, was made using 'super-macro' mode which allows this camera (Fujifilm S602) to focus as close as 0.4in (1cm). This is achieved by using the wide-angle part of the zoom range, as is evident in the amount of background seen in the third image. In the third image I have utilized the wide-angle distortion to advantage, but this may not always be suitable for the subject.

Macro and sharpness

When a camera lens is focused on a close-up subject, the area of sharpness, or depth of field, in the subject reduces. Therefore, it is normally necessary to use a small f/-number, such as f/11 or f/16, to obtain sufficient sharpness in the image (see pages 32–33). The use of small apertures may require long exposure times, necessitating the use of a tripod or other firm support such as a table (use the self-timer to fire the camera without having to touch it and run the risk of moving it).

Exposure compensation

There are many situations where the contrast of shades of light and dark, or the tones of a scene, cause auto exposure metering systems to produce an incorrect result. Matrix AE systems (see pages 36–37) reduce the number of errors produced by averaging different light readings from the scene. The three most common situations where problems may occur are: subjects with lots of light areas, subjects with lots of dark areas, and back-lit scenes (with the sun in front of the camera) with high contrast, such as a lake reflecting bright sunshine.

To help deal with these situations, digital cameras often have an exposure compensation feature. Exposure compensation allows you to tell the AE system to give more or less exposure when metering a scene.

Underexposure

Large light areas of tone, such as sand, cause the AE system to underexpose the scene. This produces dark pictures with little detail in the shadows and dull highlights.

Plus compensation

By applying plus exposure compensation the AE system will give more exposure than the original meter reading indicates. This corrects the underexposure and produces a brighter picture.

EXPOSURE VALUES

Exposure compensation is often expressed in units known as exposure values or EV numbers. For example, a typical compensation range might be written as − 2 to +2EV in 1/3EV steps. Whenever you see an EV number simply think of it as an exposure stop (a stop in photography multiplies the exposure by a factor of two and is the same as changing the aperture or shutter speed by one full value). So, if you set the exposure compensation to +1EV the camera will first determine the auto exposure for the scene and then add one stop, thus doubling the exposure for that scene. This will lighten everything in the picture.

WHEN TO USE COMPENSATION

Light-toned subjects
Predominantly light-toned subjects, such as a portrait of a blonde-haired person wearing white clothing, will fool the AE system into underexposing the picture, producing a dark image. Correct this by giving +1 or +2EV compensation.

Dark-toned subjects
Where there are large areas of dark tones, for example, in a portrait of a black person in a black suit, the AE system may tend to overexpose the subject, resulting in an image that is too light. Correct this using −1 or −2EV compensation.

Shooting 'against' (into) the light
For water or snow scenes where the sun is in front of the camera, the bright reflection may cause the AE meter to underexpose. Correct this by giving +2EV compensation. In each situation, use the camera's preview monitor to check your result.

TOP TIP

Some cameras allow 'AE bracketing.' This means the camera will take three shots of the same subject when the shutter button is pressed, rather than just one. Each shot will receive a slightly different exposure compensation, based on the amount chosen by the user. This could be useful if you are not sure how much compensation you should use.

Overexposure

With large areas of dark tone as in this statue, the AE system produces overexposure resulting in 'washed out' pictures. The image has a 'too light' look about it which our brain tells us isn't right.

Minus compensation

Applying minus exposure compensation tells the AE system to give the scene less exposure than the meter suggests, resulting in the tones of the picture being made darker. In this example, this correction has produced a more realistic result for the statue.

White balance control

Different lighting conditions produce ambient light that varies in colour. For example, late evening sunlight is very warm, and the light from household bulbs is even warmer. Digital camera CCDs are designed to produce good colour under normal daylight conditions (between 10am and 4pm summertime). When the colour of the ambient light is not close to normal the picture will show a pronounced colour cast. To compensate for these situations digital cameras are often fitted with a white balance control system. White balance is the same as using colour correction filters on the camera in film based photography.

Most cameras have an automatic white balance system that will try to compensate for changes to the ambient light colour without the user needing to do anything. The system will attempt to remove any dominant colour bias to produce 'normal' colour. Some cameras also have a manual white balance control allowing the user to select the most accurate setting (based on using a white object) for the situation. There are often set options for common light sources, such as Shade (outdoor shade often contains bluer light), Fluorescent tubes, and Incandescent lights (household bulbs).

Use the camera preview monitor to check the colours of the image and if necessary adjust the white balance to correct any noticeable colour cast.

> **TOP TIP**
>
> **For some subjects, such as portraits in evening light, a mild colour cast can be very pleasing, so always think about what you are doing before changing the white balance.**

Natural lighting

Outdoor scenes in daylight present little problem to the white balance systems of most digital cameras. For this type of picture the colours will be recorded with reasonable accuracy.

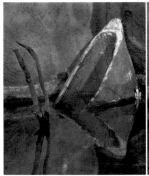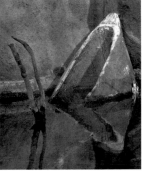

Indoor lighting (left)

The first image of this scene taken under indoor lighting has not been corrected properly by the auto white balance system. To obtain the correct colour shown in the second image, it was necessary to set the white balance system to the incandescent setting. The setting chosen depends on the light source illuminating the scene.

Mixed lighting (right)

When a scene is lit by different types of light source, as in this scene lit by a mix of daylight, fluorescent and incandescent, it is impossible to expect 'natural' colour in the picture, so choose the white balance setting that produces the colour that pleases you most.

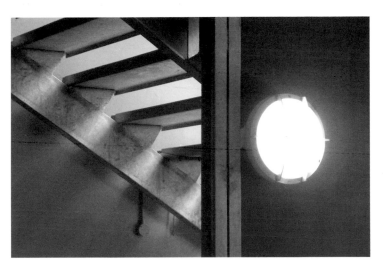

White balance bracket

This composite shows the three different colour renditions (warm, normal, cold) produced by using white balance bracketing.

White balance bracketing

When working quickly in changing conditions, or if you are not sure which white balance correction to use, some cameras allow white balance bracketing. Bracketing means taking two or more shots of exactly the same subject varying the camera settings for each. In this case, the camera will automatically take three shots of the same subject, altering the white balance for each shot.

Image adjustments

One of the exciting features of digital camera technology is the ability to alter the image in ways that would be impossible with film-based cameras. The image adjustments permitted vary from camera to camera but the most prevalent are brightness, contrast, sharpness and colour saturation control. Some of these, such as sharpness, may be set prior to taking the picture, but most adjustments are made after the exposure is made.

Use the camera preview monitor and the camera controls to alter the image while judging the effect on the monitor. Be careful not to overdo the adjustments or you risk ruining the image quality.

Low contrast

When photographing in overcast weather the resulting pictures often lack contrast, producing dull, lifeless images as shown by this picture of wood and pebbles.

Correcting contrast

By increasing the contrast after the image has been captured the picture can be brought back to life. The colour and contrast are now more acceptable.

Underexposure

If the picture has received too little exposure it will appear dark and lacking in detail in the dark tones. This is shown in the dark plumage of the duck in this picture.

Increasing brightness

By increasing the brightness of the image after capture, the picture can be lightened and more detail brought out in the dark areas. Notice the improvement in the dark feathers.

COMMON ADJUSTMENTS

Brightness
The brightness adjustment allows you to make the image lighter or darker. This is useful when the exposure was slightly incorrect and the picture cannot be re-taken.

Contrast
Pictures taken in dull light, such as overcast daylight, often look flat and lifeless due to a lack of contrast. Conversely, pictures made in strong light often have too much contrast, resulting in harsh-looking images. Both of these situations can be adjusted using the contrast settings on the camera. Increase the contrast for dull pictures and reduce it for harsh pictures.

Colour Saturation
The colours of a subject sometimes appear duller or brighter in the image than your eye perceives them. To improve the colour in the image change the colour saturation setting. Increasing the saturation makes the colours richer while reducing saturation calms them down.

Sharpness
Most images formed by digital cameras benefit from increasing the sharpness of the image. This is done by exaggerating the local contrast of details in the image, which gives the impression of higher sharpness. Be careful not to overdo this adjustment or the image will look very unnatural.

Capturing mood

Sometimes the image of a scene fails to capture the drama or mood you saw when taking the picture. Here the rainbow, although subtle, and the evening light, looked dramatic against the stormy sky. However, this is not effectively shown in this picture.

Improving mood

By increasing the contrast and adjusting the colour balance of the image I have been able to change it into a picture that creates the visual impact of the original scene as I experienced it.

55

Histograms

Many cameras have a histogram feature that is very useful once you understand how it works. A histogram is simply a graph showing the balance of brightness in an image. The higher the graph, the more pixels of a particular value exist in the image. Once an image has been captured the histogram can indicate whether the exposure was adequate or whether it would be better to redo the image with a different exposure. On cameras with an electronic viewfinder it may be possible to view the histogram as you view the image; on others the histogram is viewed using the preview monitor. The histogram will provide more accurate exposure information than the preview monitor.

Monument, Lancaster

A correctly exposed image produces the best quality print. The histogram facility

of a digital compact can help achieve the best exposure result. For reference, the histogram of this image is also shown.

Underexposure

This dark image is underexposed, resulting in a histogram that has most of its values at the left (dark) end of the range.

How histograms work

The histogram is based on 256 grey values along the horizontal axis, going from 0 at the left to 255 at the right. A grey value of 0 is black and a value of 255 is white. The height at each value shows how many pixels of that value exist in the image. When an image is given correct exposure the histogram tends to show a good distribution of pixels across the full graph. When the graph shape is bunched at the left side (with nothing on the right) it indicates that the image is either not exposed enough or has lots of dark tones and no light tones. If most of the values are to the right of the histogram it indicates that the picture is either overexposed or has light tones only.

TOP TIP

If the image on the preview monitor is not easy to assess, you should check the histogram to determine whether the exposure was correct.

Correct exposure

The same scene but given correct exposure. Notice the improvement in colour and

tone compared to the underexposed image and compare the shape of the histograms.

Overexposure

An overexposed image contains tones that are too light overall, with the lightest

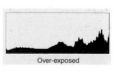

tones lacking in detail. The colours also start to look pale and diluted. The histogram for an overexposed image has most of its values to the right of the graph.

Advanced flash

Most built-in flash units go beyond the simple autoflash mode discussed on pages 40–41. Options vary on different cameras but the following advanced auto modes are fairly common: Red-eye reduction, Slow-sync, and Fill-in. There may also be combinations offered, such as slow-sync with red-eye reduction, which helps with indoor party pictures.

For flash to work correctly it must be used within the range of shutter speeds specified by the camera as suitable for flash guns. These are known as the flash synchronization speeds. In auto flash mode the shutter speed is set correctly by the camera. If you wish to use a separate flash unit or use manual flash mode, it is essential that you set one of these shutter speeds on the camera. If the wrong shutter speed is used the subject will not be recorded as expected.

Some models also have a hot shoe fitted on the top of the camera which allows a separate, more powerful unit to be attached. If this is also a dedicated flash (specifically designed for the camera) it will link to the exposure control system of the camera to allow the autoflash options to work. With non-dedicated flash units it is necessary to use the flash unit's auto system or use it in manual mode.

> **TOP TIP**
>
> **The built-in flash on many cameras will not work for really close-up shots because the camera itself blocks the light. Use a separate flash at the side of the subject, attached to the camera with a cable via a hot shoe adaptor.**

External flash

Any camera fitted with a hot shoe can utilize a separate flash unit. The flash gun cable is attached to a hot shoe adaptor allowing the camera to fire the flash. For this picture of a locust I used 'super-macro' mode to get really close and hand-held the flash gun to the right of the camera. The flash was fired into a large piece of card to create soft bounced light to simulate daylight. The flash was needed to provide a consistent lighting, obtain good depth of field, and freeze any movement of the insect.

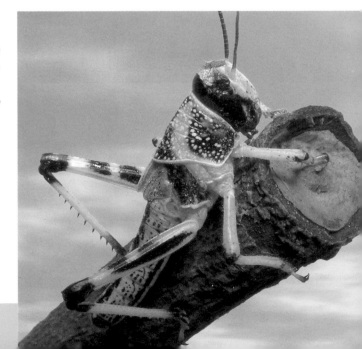

FLASH MODES

Red-eye reduction

The bright red circle seen in people's eyes when a picture is taken using built-in flash is caused by the flash light bouncing off the blood vessels at the back of the eye. Red-eye reduction mode causes the flash to fire twice: the first time is to force the person's irises to close then the second flash takes the actual picture. This does not eliminate the problem but it does make the red circles smaller.

Slow-sync

A common problem when using flash on the camera to light a subject is that the background usually appears too dark. To overcome this problem the slow-sync mode uses a slower than normal shutter speed combined with the flash to allow the ambient light to brighten the background.

Fill-in mode

When photographing a subject against the light or in a shady spot it often happens that the 'correct' exposure for the overall scene leaves the main subject too dark. To correct this situation use fill-in flash, which is a small amount of flash used to lighten the shadow parts of an image (This is a technique commonly used by wedding photographers.) The camera will determine a combined ambient and flash exposure that produces a good balance of light on the subject.

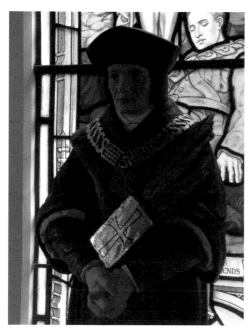

Fill-in mode – no flash (left)

When the background is bright, such as when a window is directly behind the subject as here, the meter system may cause the main subject to be underexposed. Increasing the exposure will lighten everything. resulting in loss of detail in the window glass.

Fill-in mode – with flash (right)

By setting the camera to fill-in flash mode the exposure it uses will be a combination of the light from the bright background and light from the flash on the foreground. The balance may be adjusted to achieve the desired result. As can be seen, this produces a much better result. The warm colour of this image is due to the colour control of the Fujifilm S602: when using flash, it can be too warm.

Low light scenes

Lit by only a small quantity of light, low light scenes include candle-lit portraits or night scenes. This type of lighting often results in relatively high contrast producing large very dark or black areas in the picture. These areas can cause problems for the CCD in digital cameras, resulting in electrical noise in the image.

Long exposure times of 8 seconds or more are often required by night scenes and this also tends to cause electrical noise problems with many CCD devices.

To combat this problem, many cameras incorporate a noise reduction system that helps reduce or eliminate the unwanted coloured pixels caused by excess electrical noise in the dark areas of the image. Noise reduction systems often use a multiple exposure process that allows the system to compare two apparently identical images. Any differences in the dark areas are assumed to be 'artefacts' and these are replaced from nearby pixel values.

Last light

Often, after a storm or low cloud, as dusk approaches the sunlight will break through and illuminate the landscape for a few minutes. Digital cameras provide long exposure times to cope with low light situations such as this.

Night light
This image of a street lamp shows the type of high contrast often associated with night-time pictures. Long exposure times and a good tripod are needed to capture such scenes.

Electrical noise and artefacts

Electrical noise occurs when the circuitry of the CCD and the controlling software get confused about the light levels reaching the CCD. This results in random coloured pixels appearing, mainly in the black areas of the picture. These unwanted pixels are called artefacts, which is also the general term used for any unwanted rogue pixels left behind by image editing (e.g. too much sharpening can produce artefacts).

Electrical noise
Some cameras can leave occasional pixels in black areas with odd colours when dealing with low light or night scenes. Since this noise is always random (i.e. it occurs in different places on each exposure), cameras with noise reduction make two exposures of the same scene and compare them for differences in the darker areas. Any noise is corrected by the camera software.

Dynamic range

The ability of a digital camera CCD to capture very low and very high levels of brightness is limited by the dynamic range of the CCD. In bright sunshine some subjects have very high contrast (the difference between the darkest and lightest parts of a subject is called subject contrast) which may exceed the dynamic range of the CCD.

To extend the useful dynamic range of the CCD and therefore increase the range of lighting conditions that the camera can deal with, some cameras use an extension of the noise reduction method. In this system, the camera uses multiple exposures of the same scene but then averages the pixels of each exposure.

Clear image mode

Nikon name their extended dynamic range system Clear Image Mode and incorporate it into their higher end cameras. One of the limitations of the system is that any movement of the subject or camera during the exposure will result in a blurred picture. Since the system uses multiple exposures, any movement between each exposure will produce two different images and not simply different exposures.

Since the camera is using two CCD pixels to form one image pixel, the largest image size possible using this feature is half the maximum of the camera.

Lighting contrast

Most subjects that are lit with the sun behind the camera have a contrast range that the CCD can handle quite easily. This type of subject, when correctly exposed, will produce excellent prints with good detail throughout the tones.

Subject contrast

When the subject has an inherently high contrast such as this water lily and leaves, it is important to make the picture with soft lighting to avoid the overall contrast exceeding the dynamic range of the camera CCD.

High contrast

When the subject has high contrast and the lighting is also high contrast it may not be possible for the CCD to retain overall detail in one exposure. This semi-abstract demonstrates the problem. As can be seen in the two smaller images, no one exposure was right for the subject. A camera with dynamic range enhancement, such as the Nikon Clear Image Mode, can combine different exposures in one image to improve the detail in the picture.

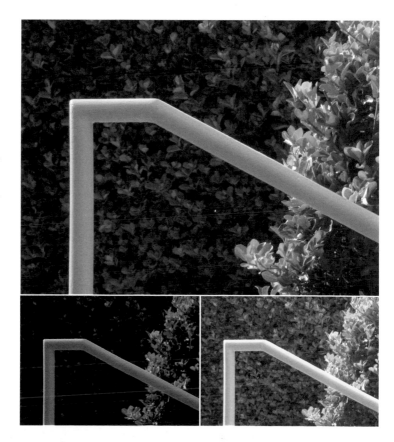

Improving sharpness

Any movement of a hand-held camera during the exposure will cause a blurred image. This can occur most when using the camera zoom lens at the maximum telephoto setting, or when using macro mode for close-up pictures. This common fault is known as camera shake and is characterized by either a double image or, in extreme cases, a streaky image. This is not the same as an out-of-focus picture taken with a static camera, which is caused by inaccurate focusing of the lens. One of the refinements that digital cameras allow over their film-based counterparts is the ability to compare the sharpness of two or more images and indicate which is best. This is known on some cameras as Best Shot Selection. It is achieved by making a series of images of the same subject, from which the camera selects the sharpest. The user then saves the selected image.

Organic sharpness
Organic subjects such as this flower can appear to have a gentle sharpness since there are not really any definite edges. Static subjects like this can benefit from the use of a tripod to allow the optimum aperture to be selected.

Avoiding camera shake

The Best Shot Selection system is found on some Nikon cameras but for cameras without this feature there are some practical steps you can take to reduce the risk of camera shake spoiling your picture.

When hand-holding a camera, try to use the fastest practical shutter speed (bearing in mind the depth of field requirements of the picture). Adopt the correct position for using the camera bracing your arms against your body, and breathe out just before squeezing the shutter button. These measures will minimize the movement of your body and produce sharper pictures.

The ideal method of keeping a camera still is to use a tripod. This will be essential for many types of subject, such as night scenes, because long exposure times will be needed. The best tripods are quite heavy but a useful device is a mini-tripod which can be stood on any flat surface.

Camera shake

This image, left, was made with a slow shutter speed of 1/40 and shows marked camera shake. Compare with the sharp version of the same subject made at 1/250.

Out of focus

This image has not been focused accurately and is quite soft. Compare this to the camera shake image to see the difference. Sometimes the auto focus system will not be accurate (as here) and manual focusing is required.

TOP TIP

To avoid camera shake use a shutter speed faster than the focal length of the lens being used.

Movement

When shooting action such as sports or dance, it is often difficult to capture the exact moment when the best picture occurs. With film-based cameras, the usual way to deal with this problem is to use a motordrive and shoot a sequence of pictures covering the period of peak action, hoping that one frame will have caught the decisive moment.

Digital cameras also permit a sequence of images of a subject to be taken – usually referred to as continuous shooting mode. One major problem when shooting a sequence with a digital camera is the time it takes the camera to process each image. This may limit the speed of capture. With film cameras a motordrive can shoot 10 frames per second because the image is recorded in an instant. With digital capture this is reduced to between two and five frames per second for high quality results.

Sequence options

To increase flexibility, various sequence capture options may be available for different situations. Some cameras permit a number of frames to be exposed and then store either the first or last few frames depending on which option is selected by the user. Which method is used depends on the action being photographed. When you are following the action by moving the camera, known as panning, saving the last few frames is the best choice. When the camera remains static, saving the first few frames will record the action as it progresses. Although these methods are good they do not always guarantee that the exact moment of the peak action will be captured correctly. You'll find that the success ratio will improve as your experience grows.

Blurred movement

It is often useful to allow moving subjects to blur to create the feeling of speed and excitement. This is achieved here by using a shutter speed of 1/100 second. The amount of blur depends on several factors: the subject's speed, the shutter speed used, the direction of travel (movement from side to side blurs more than the same movement towards the camera) and the distance from the camera.

Random motion (below)

This sequence shows the difficulty of trying to capture random movement. Since it was impossible to anticipate the flight path of this kite, and due to the delay between pressing the shutter button and the image being captured, I found it extremely difficult to stop the action exactly where I wanted it. Some of the results are shown here.

 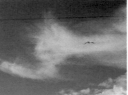 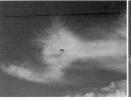 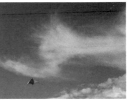

Sequence mode

When the movement being captured follows a known path, as in this roller coaster ride, it is possible to use the continuous shooting mode to record several images in sequence. By anticipating the start and end point of the movement it is possible to make sure the sequence records what is required. Here, the fourth frame in the sequence gives the most pleasing result.

Movie making

A fun feature of most digital cameras is to extend the sequence idea to allow short movies to be recorded, similar to a camcorder. Because smooth motion in a movie requires at least 24 frames per second, and since the image processing speed slows the process, the image pixel size of these movies is relatively low, currently 640 x 480 pixels. However, movie capture is the best option when you want to capture something that relies on movement to tell a story, such as a child's first steps, making movies for websites, or producing training CDs. On most cameras it is also possible to record sound with the movie to convey atmosphere or even to add a voiceover.

Movies are stored in Motion JPEG AVI format and can fill storage memory quickly so make sure you have enough memory capacity. Movies can be played back either on a TV using an AV cable or on a computer using software such as Apple QuickTime. Using video editing software you can also add titles and special effects to the movie.

Movie sequence

This series of stills was taken from a movie shot to analyze a TaeKwonDo kick technique. The movie facility is ideal for producing short movies to be used as teaching aids.

Flying side kick

Due to the limited resolution of a digital movie it is not possible to use stills from the movie for larger prints. To obtain a good quality still, such as this action shot of a flying side kick, it is still necessary to use other techniques.

Accessories

Depending on the sophistication of the camera it will either be supplied with, or have available as optional items, a range of accessories designed to extend the use of the camera.

For everyday use of a digital camera it is helpful to have at least the following items: rechargeable batteries and charger, a mains adaptor (this may be combined with the charger) and cables to connect to a computer and/or TV. Many camera kits include these basic items but it is worth checking before purchase.

The more complicated cameras are often known as system cameras because the camera is the central part of an entire range of items designed together to expand the capabilities for the user. Typical system accessories include: high capacity

batteries, lens converters, external flash units and flash cable connectors, various media card adaptors and carrying cases. Even dedicated printers may be considered part of the system.

Although you may initially buy a digital camera simply for holiday snaps, it is surprising how many people later get hooked on photography as a serious hobby. Therefore, it is worth considering the expansion possibilities of the camera you buy to avoid having to buy another camera later if your interest develops.

Telephoto image

Using a telephoto adaptor increases the maximum focal length of the camera's zoom, allowing subjects further away to be isolated. The curving of the lines in this image of skyscrapers is caused by pincushion distortion, which is a problem with long telephoto lenses.

Telephoto attachment

Telephoto attachments, such as this one from Nikon, increase the photographer's creative options by extending the maximum focal length of a fixed zoom.

Wide-angle image

The wide-angle adaptor allows the minimum focal length of a zoom to be reduced. As shown in this complex composition of London monuments, extreme wide angles cause barrel distortion. This is particularly noticeable on the flagpoles, which are vertical. On the organic shape of the sculpture on the left it is less apparent.

Wide-angle attachment

By extending the lowest focal length of a fixed zoom, wide-angle attachments allow a wider range of subjects to be photographed.

System chart

This chart shows the extensive range of items available in the Olympus E-Series camera system. System-designed accessories complement the main camera perfectly and extend it's capabilities.

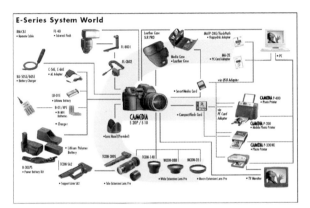

E-Series System World

Lens adaptors

Although most digital cameras have a versatile zoom lens fixed to the camera, as your interest grows you may find the zoom range inadequate. In this case, the best way to expand your picture taking possibilities is with a lens adaptor. Lens adaptors are designed to increase the zoom range of the camera lens while maintaining image quality. Wide-angle and fisheye adaptors reduce the lower focal limit of the zoom to allow more of a subject to be included from the same viewpoint. Wide angle focal lengths are also great for producing distortion effects. Telephoto adaptors increase the upper focal range of the zoom. This allows more distant subjects to fill the picture (rather like a telescope) and is useful when you cannot move closer. A third type of lens addition is the macro adaptor. A macro or close-up adaptor reduces the nearest distance the lens will focus on. This allows you to move much closer to a subject, such as a flower, to fill the picture with a small detail.

4

Making sense of software

It is impractical to store your digital camera pictures on memory cards in the long term, due to the relatively high cost and the inconvenience of such storage. A better option is to transfer the images onto a computer hard drive and work with them from there. A computer hard drive can store far more images than memory cards, is more economical and is more convenient for subsequent editing and viewing of the images.

Of course, having numerous image files on a hard drive is not very useful without some kind of software program to help you work with those images. Camera makers usually provide additional software with their products, and this can range from a simple proprietary image viewing and cataloguing program, such as Fujifilm's FinePix viewer, to more sophisticated programs like Adobe's PhotoDeluxe Home Edition or Adobe Photoshop LE, which allow image manipulation.

There are also more specialized computer programs available, either online or from computer stores, that extend the creative possibilities of digital images.

This section will explain how to transfer camera images to a computer and take a brief look at the typical software supplied with digital cameras and what can be done with it.

Abstract statue
Once the image is stored in a computer it can be manipulated in countless ways to achieve almost any result you desire. Here is an example of a heavily manipulated image that started as a simple record of a statue.

From camera to computer

There are various methods available for transferring pictures stored on camera memory cards or MicroDrives to a computer. The easiest and most direct is to connect the digital camera to the computer using a USB (Universal Serial Bus) or Firewire cable. These are usually supplied with the camera but can be purchased from most photographic or computer stores. The camera will usually be supplied with driver software, which needs to be installed on the computer before connecting the camera. With Microsoft Windows, based computers, USB is part of the system and should recognize the camera as soon as it is connected to a USB socket on the PC.

Once the camera has been detected by the computer, the associated viewing software supplied with the camera (this needs to be installed on the computer first) will launch and start to display the pictures stored in the camera.

TOP TIP

Always install the supplied driver software before connecting the camera to the computer for the first time.

Using external devices

It is also possible to transfer images direct from a memory card, without the camera, to a computer using a PC Card Reader or Image Memory Card Reader. To use these external devices simply connect the device to the computer using the appropriate cable and insert the memory card in the reading device. The image viewer software can then be used as usual.

The memory card can also be read directly by the computer using a PC card adaptor or a floppy disk adaptor and the appropriate slot on the computer (e.g. a floppy drive or PC card slot). This is convenient for laptop computer users.

Card reader

Simple-to-use card readers like this one are available from various suppliers. This typical model is made by Delkin Devices in the USA.

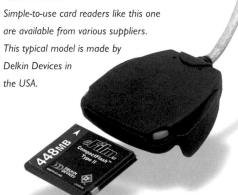

PC card adaptor

A card adaptor, such as this one from Delkin Devices, allows a Smartcard to be inserted and then plugged into a compatible slot on a computer or other device (such as a printer).

Microdrive adaptor

These are of a different design from Smartcard types and the two are not usually compatible. It is usual to buy the adaptor with your first microdrive.

Camera to computer

Transferring images from the camera to a computer allows the digital magic to continue.

Floppy adaptor

For computers with a floppy drive slot, this type of adaptor accepts Smartcards, allowing them to be read from any floppy disk drive.

Image viewers

The image viewing software supplied with a digital camera is designed to make it easy to download images from the camera's storage media onto a computer hard drive. The viewers work like a media file manager, showing small thumbnail previews of each image on the storage card. The image files are sequentially numbered by the camera file system when originally created, and this is the filename initially displayed by the viewer. When transferring the images to your computer, it is a good idea to give each image file a unique name that will identify the subject. This makes it easier to locate the required images later.

Some image viewers also allow you to carry out file management tasks, such as creating and organizing folders, moving images to different folders and deleting unwanted images. Once the images have been transferred to the computer, the memory card can be cleared ready for further use in the camera. A useful feature of some proprietary image viewers is the facility to connect to the manufacturer's website. These websites often contain useful information and also allow images to be uploaded to online galleries, or many enable you to have prints produced and returned to you by post.

Viewing thumbnails

This screenshot of the image viewing software supplied with the Fujifilm FinePix S602 shows how the images stored on the camera or a computer hard drive can be viewed as small thumbnail images. Selecting an image brings up the information about how the image was created on the right-hand side of the display.

List view and websites

When dealing with dozens of images it can be useful to display a list of the image files, as shown in this screenshot. This allows more efficient management of the image files and folders. Image viewers from manufacturers who also have a website often integrate the web features into the image viewer, as can be seen here on the right of the viewer display (compare with the lower screenshots).

Folder tree

The information shown in the image viewer can be changed to suit the task in hand. In this screenshot the folder management tree has been made visible in the left-hand pane of the display.

Enhancing images

Although some digital cameras have facilities to make enhancements to the image after the exposure is made, it is usually better to do this kind of work using a dedicated image manipulation package on a computer. Image software, such as Adobe PhotoDeluxe HE or Photoshop LE, is often included with a new digital camera. If you have access to such software it is a good idea to make sure the exposure and colour are good when taking the picture and leave contrast, sharpening and other corrections

TOP TIP

Before doing any work on an image make a backup copy of the original unmodified file in your viewer program for safe-keeping.

or enhancements until the image is on a computer. This is because the dedicated image programs are far better at manipulating image data than the limited software built into the cameras. The basic tasks you may need to perform on a newly

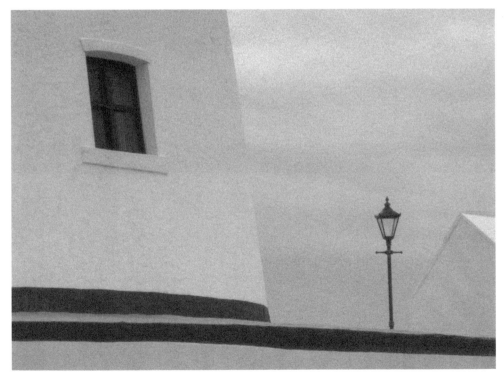

Old photo look

This is the final image after applying special effects filters to the image in Adobe PhotoDeluxe HE.
The permutations possible with effects filters are limited only by your imagination.

downloaded camera image are: contrast adjustment, colour balance, and sharpening (ready for printing). These tasks are the same as those described on pages 54–55 in Image Adjustments.

The real fun of digital imaging comes when you start to use the image software to manipulate the picture in ways that were previously impossible. Most software comes with a collection of special effects filters and these are a great place to start giving your photos a new and creative look. The examples here show only a few of the limitless possibilities.

Manipulation software

These screenshots show the interface for the Adobe PhotoDeluxe HE software supplied with the digital camera. The display shows thumbnails of the images in the open folder on the left which, when selected, open the original image file in it's own window ready for use. Beside the usual image correction facilities of contrast, colour balance and sharpening, the upper screenshot shows the special effects menus being used to change the windmill image. The changes are made by simply using your computer mouse to select the options you want.

Pop art

Creating zany pop art effects is easy using computer software. Although effects filters can make any image look different, it helps to start with a good picture and enhance it, rather than trying to rescue a poor picture.

5

Outputting images

The majority of people take photographs for the purpose of sharing precious moments or important events with family and friends. Therefore, we need some way of showing the images stored on a digital camera or computer to a wider audience.

The traditional method of showing images is as prints, made at a photo lab or local photo print shop. Most of these photo outlets now accept digital media, either memory cards, CD, or some other portable storage media. There are also companies providing online digital printing services. In fact, most labs now produce digital prints, even from traditional colour negatives.

Prints are ideal media for showing pictures since they can be produced in various sizes to suit the purpose. With digital imaging, prints no longer have to be made by professional labs: it is now quite easy to make them at home. Various home printing systems exist depending on what equipment is available. For non-computer people a dedicated system photo printer, such as those from Olympus and Canon, produces outstanding results. For the more ambitious, several models of inkjet printer can accept camera memory cards and print directly from the images on the card. For those wanting the greatest creative versatility, a computer and good quality photo inkjet printer will permit image manipulation and various sizes of print to be produced.

Digital images increase the options available for presenting the finished images in addition to prints. Digital cameras can be connected directly to a TV using a video cable, allowing still images, slide shows, or movies recorded by the camera, to be shown in comfort and at no extra cost. A computer expands the possibilities, since digital images can be uploaded to the internet, either for displaying on web pages or sending to friends via email.

Spiked stems
Manipulating an image is only one step in the process. Most people will want to enjoy their creations by having prints made, ready to display to others.

Printing services

Digital cameras are specifically designed to facilitate the use of digital printing services using a system known as Digital Print Ordering Format (DPOF). This special system allows the camera user to create a Print Order which is used by DPOF compatible printing machines, either professional or home-based, to print the required images. The print order specifies the images on the media card to be printed, the number of prints required, and any information to be overlaid on the print. All this information is stored on the media card in the camera and later read by the digital printing machine to fulfil the order. Using DPOF with a compatible desktop printer at home makes it easier to produce your own prints.

Most professional labs and photo print shops will print digital images stored on a variety of media (e.g. Smartcards, CDs, zip disks) onto traditional colour print paper. These prints are usually inexpensive and of high quality. Some camera manufacturers and professional print labs also have websites specifically designed to allow users of digital cameras to upload digital files and have prints made and returned by post.

Pixels and print sizes

It is essential that the digital files supplied for printing are of the correct pixel size and quality in order to produce the best prints. Therefore, images destined for printing should be recorded at the largest pixel size and the highest quality setting to allow prints of various sizes. To determine the ideal pixel dimensions required for a particular print size, simply multiply the print size in inches by 300 pixels. For example, a 6 x 4in print requires a digital image of 1800 x 1200 pixels. If the pixel size is correct but the quality setting is reduced when creating the image file, the print may appear fuzzy and details will be lost.

Kodak digital prints

This is typical of the type of Kodak 'digital print station' found in high street photo shops. A variety of media can be read by the machine e.g. CD, SmartMedia cards, floppy disks. The images are transmitted to a Kodak lab and the prints returned by post.

Sample prints (opposite)

As can be seen from the sample prints shown here, you can add borders or change the size of the image within the print paper using digital image editing software prior to printing.

Dedicated printers

For digital camera users who wish to produce their own prints but do not want to become involved with the steep learning curve that computers require there are dedicated printers available. These printers are designed to accept camera memory cards and produce high quality prints with the minimum of fuss. Most can also be used to print images from a computer or TV monitor.

Dedicated printers, such as those from Olympus, range from portable units (producing postcard-sized prints) that can be used anywhere, to highly sophisticated desktop machines, which produce stunning A4 prints. Additionally, each printer model usually has progressively more advanced options for controlling the print output.

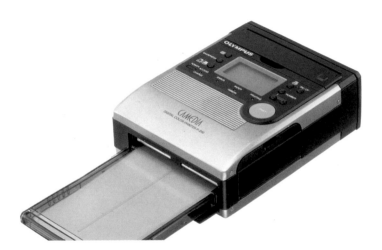

Ultra-compact printer
The smallest printer in the Olympus range, this machine is dedicated to printing index card-sized prints at a fast speed.

Postcard printer
This device creates high-quality prints measuring approximately 4 x 5.5in (10 x 13cm). This printer can also be connected to a TV for viewing the images.

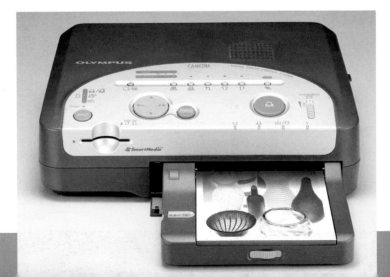

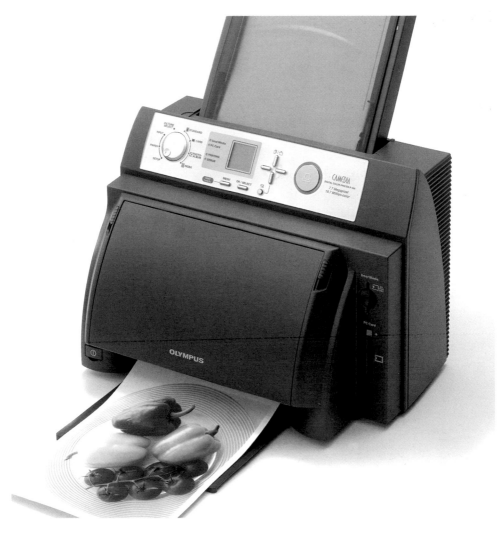

Professional printer

This is a professional quality printer that produces long-lasting A4 size prints. As well as accepting SmartMedia cards, the printer can also be connected to a computer.

Dye sublimation transfer

Most dedicated printers are based on the dye sublimation process, which produces the best photo quality. Dye-sub printers produce very smooth tones and vibrant colours, resulting in luxurious-looking prints. This quality is achieved with the use of specially prepared paper. This paper produces prints that are both durable and water, resistant. They are also very fade-resistant, making them long-lasting when displayed in frames.

Inkjet printers

The commonest type of photo quality printer for home use is the inkjet type that uses ink or pigment. These printers are inexpensive to buy and are capable of outstanding print quality. The majority of inkjet printers are designed to be connected to a computer to allow images stored there to be printed.

Paper Selection

Unlike dye-sub printers, which require a special type of paper, inkjet printers can use a wide variety of coated materials. An extensive range of papers (and canvas) is available from numerous makers for inkjet printing. Inkjet papers are also available in various surface

How inkjet printers work

Inkjet printers produce the image by spraying minute droplets of coloured ink or pigment onto the paper surface. To form the various colours of the image, different amounts of each colour of yellow, magenta and cyan are sprayed onto the paper. These dots of colour are so fine the human eye sees them blended as the required colour. To produce the darkest colours and tones of an image black ink is added, this also produces the deep blacks of an image. Inkjet printers use either a four- or six-colour system depending on the model. Four- colour models use only the colours mentioned; the six-colour versions utilize additional paler inks of magenta and cyan. Ink colours are usually referred to as CMYK (the letter K refers to black, derived from traditional printing terminology).

Inkjet printers are available in a variety of sizes, from A4 up to professional large-format machines.

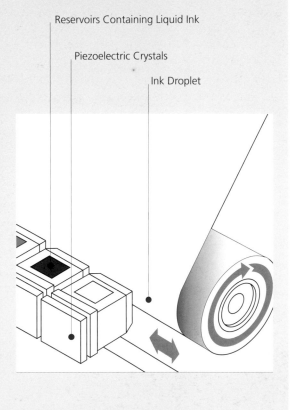

Reservoirs Containing Liquid Ink

Piezoelectric Crystals

Ink Droplet

finishes: high gloss, satin, semi-matt, full matt, and even textured surfaces. This variety offers scope for selecting just the right paper for your personal printing requirements.

Printing from memory cards

Although most inkjet printers are connected to a computer, some models also have a media slot to accept camera memory cards for use by people without a computer. This gives non-computer users the choice of using either dedicated dye-sub or inkjet printing.

Print Image Matching

Print Image Matching (PIM), developed by Epson, is designed to make it easier to produce prints from a digital camera that closely match the original subject. Normally, unless using a sophisticated calibration system, when you print an image from the computer the printed picture will not exactly match what you see on the computer screen (in many cases it will be wildly different). The PIM system, which is likely to be included in most digital equipment, stores specific details of the way the camera recorded the scene. This information is then read by another PIM compatible device (such as a printer) and controls the settings used to make the print. In this way it should be possible to obtain 'correct' prints first time with little intervention from the user.

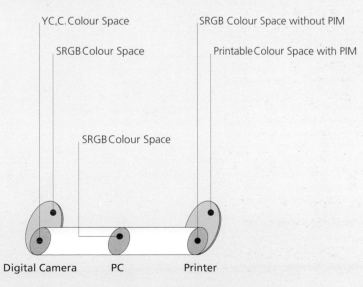

YC,C, Colour Space

SRGB Colour Space without PIM

SRGB Colour Space

Printable Colour Space with PIM

SRGB Colour Space

Digital Camera PC Printer

Contact prints

Digital images require lots of storage space and it doesn't take long before your camera media or computer hard disk is bursting at the seams. The most economical mass storage medium is compact disk (CD). With a CD writer and a stack of blank disks, you can transfer all your digital files to CD and make space on your camera or hard disk.

However, once the images are stored on CD you cannot know what that CD contains without returning it to the computer and using your viewing software. Although image viewing software is great for looking at your images, it is not very convenient when you have a dozen CDs and you want to know quickly what they contain, or find a particular image.

The solution is to make contact sheets of the images on each CD and label these in some way so they can be associated with the relevant CD. The term 'contact sheet' comes from traditional photography where a set of film negatives were laid on top of printing paper (in 'contact') and exposed to light to make a contact sheet. This is how photographers catalogue their negatives. The same idea works for digital files and there are various pieces of software available that can print a series of small images (known as thumbnails) from digital files onto a single sheet of paper via an inkjet printer.

For the examples shown here I used Adobe Photoshop, which has an automatic facility for generating contact sheets. Once the images have been transferred to the CD, the software reads the images on the CD and makes the contact sheets. The same method can also be used to make contact sheets from images stored in any folder on a hard disk. Photoshop provides various options, such as page size, number of images per page, and any labels for each thumbnail.

Once the contact sheets have been created, additional text information can be added in Photoshop to identify the source of each image (e.g. a unique reference number). The contact sheets can then be organized in ring binders for easy access while the CDs can be similarly numbered (use an indelible pen) and stored. When you wish to browse through your images, it is much easier to flick through a binder of contact sheets than constantly changing CDs on the computer. Other software is likely to provide different options for creating contact sheets.

Sample contact sheets

These contact sheets were created in Adobe Photoshop. Additional filing information was added to the sheets before printing.

Arcade Leeds 1

Arcade Leeds 2

Banner

Beach huts

Blue fish

Bottle 2

Bottle 2

Car

Flower

Goblin mask

Green Leaf

Grif detail

Horses 1

Hut

Hut b

Kodak

Lillie

Locust

Microdrive

Montp

movie1

movie5

Rainbow

Reservoir and blocks

Reservoir and blocks 2

Reservoir

Rock garden

Rock in grass

Rock in grass 2

Rocks in water

Rock pool

Roller1

Roller2

Roller4

Roller3

Roller5

Sail

Sail and two trees

Sailboat 1

Sail and tree

Stairs and light

Statue

Shark

Sheep and posts

Statues Bolton

Strawberry

Disk: #12 Date: 20

Disk: #10 Date: 18/7/02 Name: © Les Meehan 2002

20/7/02

KODAK CD-R
Ultima

12

AK CD-R
Ultima

10

© Eastman Kodak Company

Power sources

It has to be made clear that digital cameras are power hungry. There are so many electronic devices in these cameras that they seem to run out of power in no time at all. Unfortunately, the only way to make the cameras portable and mobile is to use small, easily transported power sources.

Batteries

The current state-of-the-art battery is the rechargeable NIMH (Nickel Metal Hydride) type found in many digital cameras. The most beneficial aspect of rechargeable batteries is that, although expensive to buy, they remain in use over a long period with regular charging from the mains. Although battery technology is quite advanced, the reality is they will run down when you least want them to, so always carry a complete set of fully charged spare batteries in your camera kit. For more sophisticated cameras that may be used in

Batteries
Various sizes of battery are available for different cameras. It is important to use only the type specified for a particular camera.

Battery charger
There are various independent battery chargers available but make sure the charger and batteries are compatible to avoid damage to the batteries or worse.

TOP TIP

To conserve battery power, use the preview monitor sparingly and make a habit of switching it off after use (this also applies to the flash).

very cold conditions or when a longer battery life is needed between charges, some makers supply a remote battery pack. In cold weather this can be kept in a warm pocket while the camera is used to prevent the cold flattening the battery. These external packs are also useful when you want to take lots of pictures without recharging.

You should use the recommended batteries for your camera. Cheap batteries will not last as long per charge and may even crack and leak in the camera.

AC adaptors

Most camera makers supply a mains electricity adaptor for use with their cameras. This is useful when using the camera indoors, for still-life or portrait set-ups, and when the camera is connected to a computer or other machine for transferring the images.

If you take the camera and adaptor to another country make certain that the power supply is compatible with the adaptor you are using, otherwise you may not be able to charge properly and may even damage the equipment.

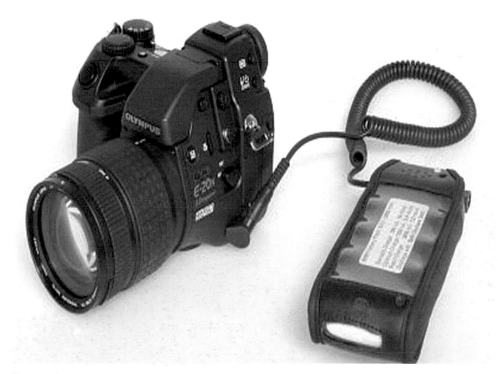

Remote battery

When you need the batteries to last a long time, or when shooting in extremely cold weather,

consider buying a remote battery. These generally have a higher capacity than the smaller types

and can be kept warm in an inside pocket in cold conditions.

Interfaces

Digital cameras can be linked to other equipment in order to view or download the picture files. This means the camera must be able to 'talk' to other equipment in a common language, known as an interface, so that information can be passed between them successfully. The current interface standard for digital cameras and PCs is known as USB (Universal Serial Bus). USB allows you to connect to any other USB-compliant equipment, such as a computer or printer. For Mac users (and some PCs) the connection is via Firewire, a fast interface system well suited to large image files.

Most cameras have various other connection options built in. These are: AC In for mains power, AV (Audio/Video) output for connecting to a TV, and possibly a remote control socket to allow the camera to be controlled from a distance with an electronic triggering device.

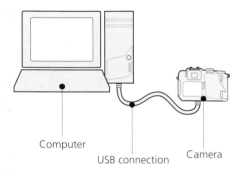

Computer

USB connection Camera

Computer connection

Use a good quality USB or Firewire cable to connect to a computer. Most cameras are supplied with the correct cable.

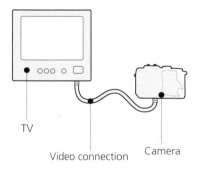

TV

Video connection Camera

TV Connection

For the best image transfer to a TV, use a high quality AV cable. If not supplied with the camera, these are available from good TV or electronic accessory outlets.

Audio/Video output

The AV output sends a TV signal in either PAL or NTSC form, depending on the local TV system. This allows the camera to be connected to televisions in different countries. It is important to use a good quality AV cable to maintain image quality. Connecting the camera to a TV allows you to show your pictures in sequences, like a slide show. This is convenient and fun for family gatherings when showing your latest pictures, and it doesn't require the room to be darkened as with film slide projectors.

AV output (opposite)

A camera's AV Out socket allows the camera images to be displayed on a television; this is a great way to view your pictures in comfort.

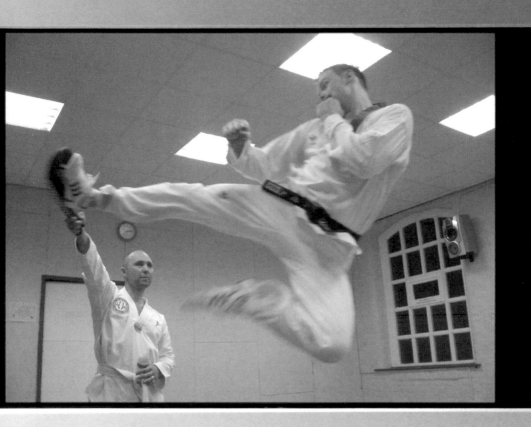

Index